THE UNOFFICIAL

THE
CROWN
COLORING BOOK

ILLUSTRATED BY
WESLEY JONES

becker&mayer! books

Brimming with creative inspiration, how-to projects, and useful information to enrich your everyday life, Quarto Knows is a favorite destination for those pursuing their interests and passions. Visit our site and dig deeper with our books into your area of interest: Quarto Creates, Quarto Cooks, Quarto Homes, Quarto Lives, Quarto Drives, Quarto Explores, Quarto Gifts, or Quarto Kids.

Published in 2021 by becker&mayer! books, an imprint of The Quarto Group, 11120 NE 33rd Place, Suite 201, Bellevue, WA 98004 USA.
www.QuartoKnows.com

becker&mayer! books titles are also available at discount for retail, wholesale, promotional, and bulk purchase. For details, contact the Special Sales Manager by email at specialsales@quarto.com or by mail at The Quarto Group, Attn: Special Sales Manager, 100 Cummings Center Suite 265D, Beverly, MA 01915 USA.

21 22 23 24 25 5 4 3 2 1

ISBN: 978-0-7603-7350-7

Library of Congress Cataloging-in-Publication Data available upon request.

Illustration: Wesley Jones

Printed, manufactured, and assembled in Guangdong, China, 07/21

#347008

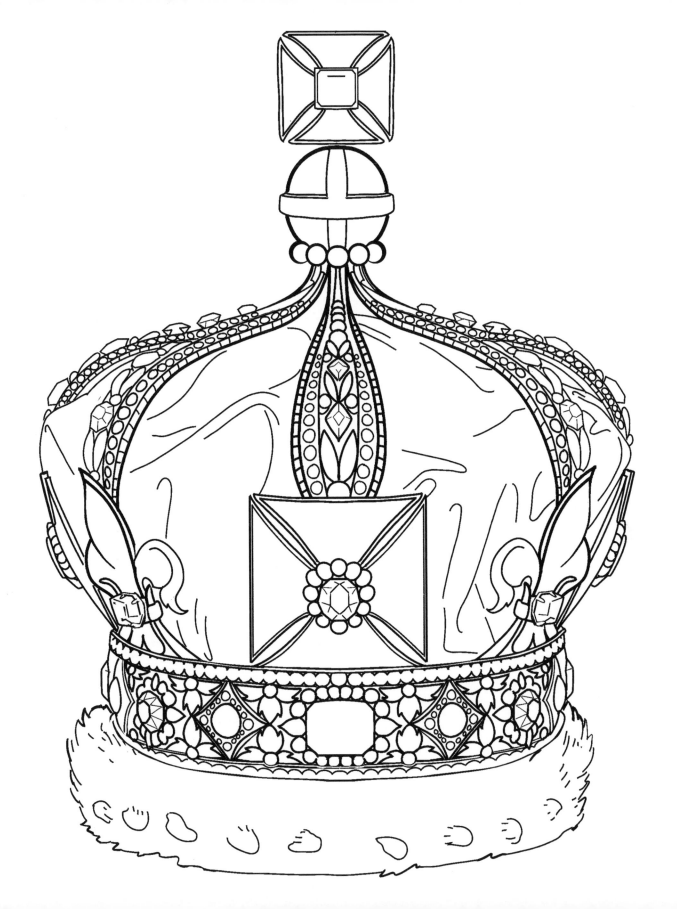

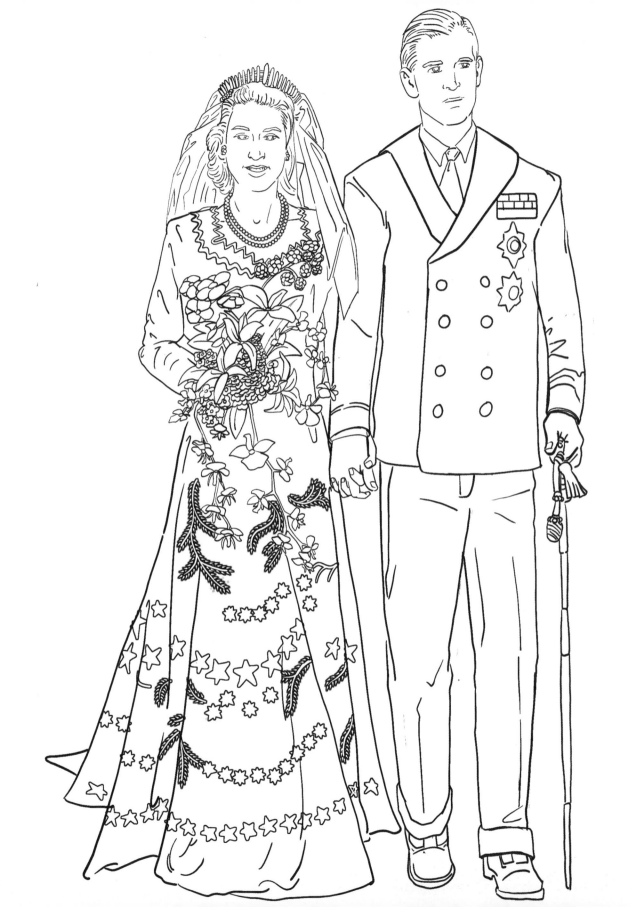

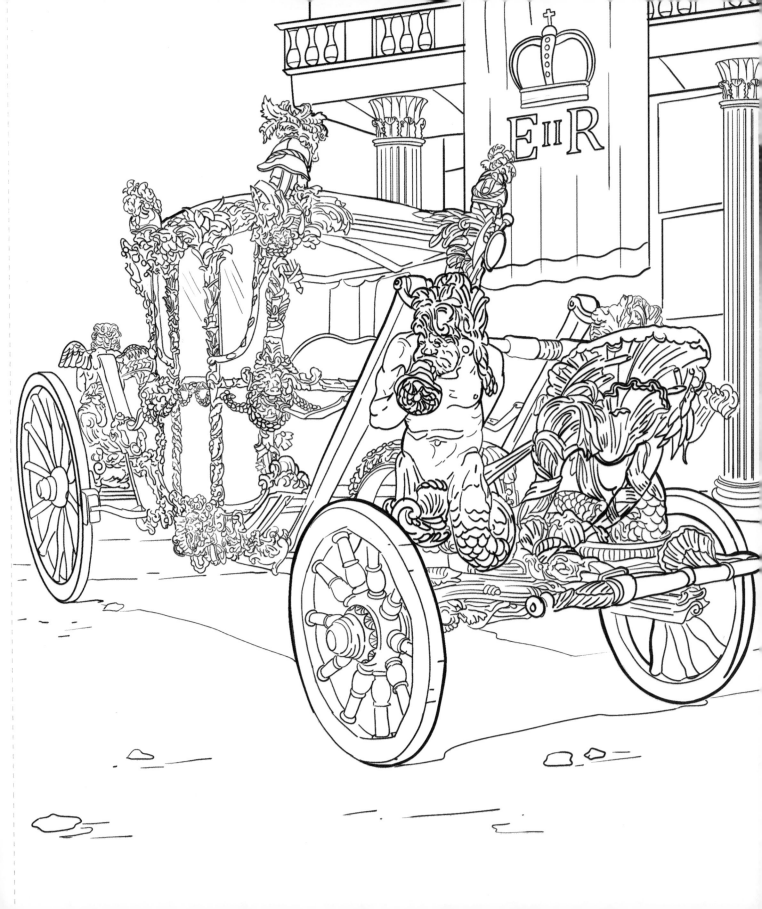

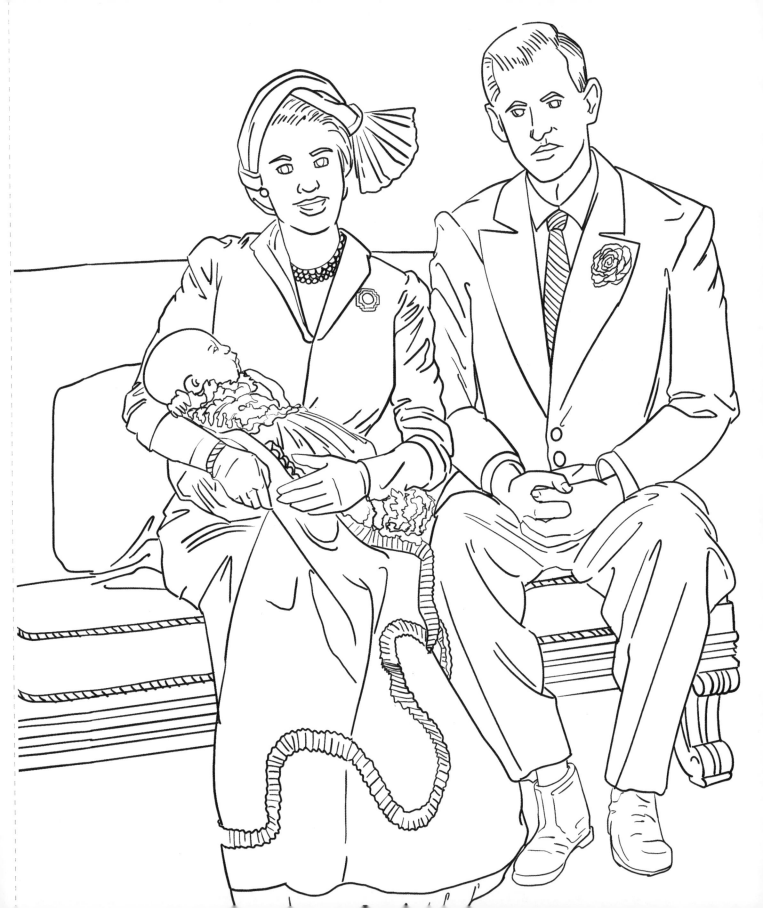

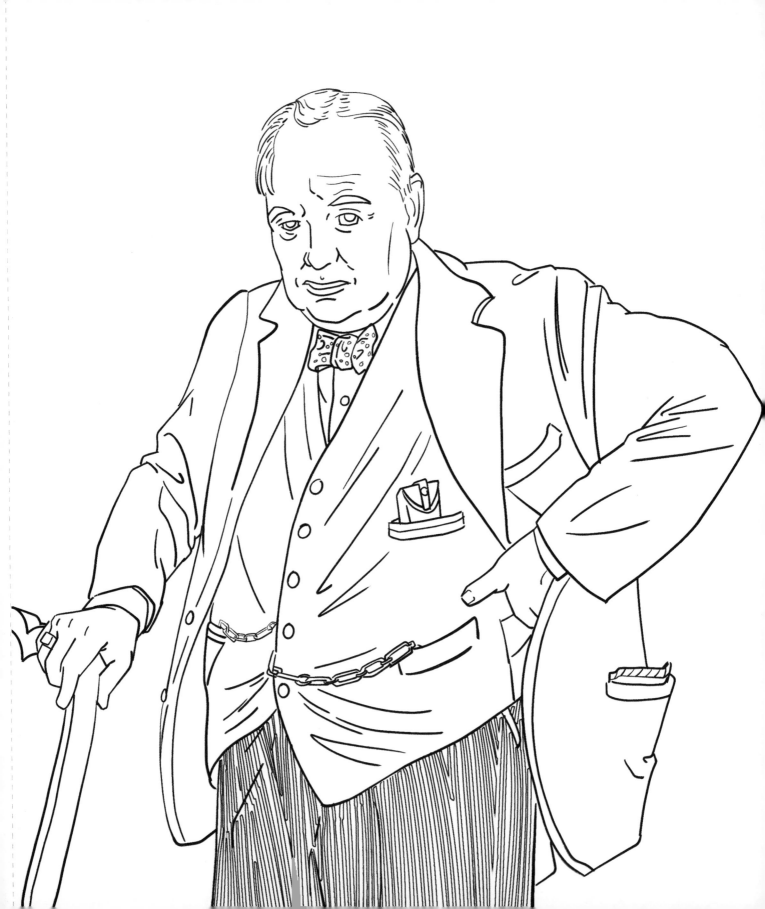

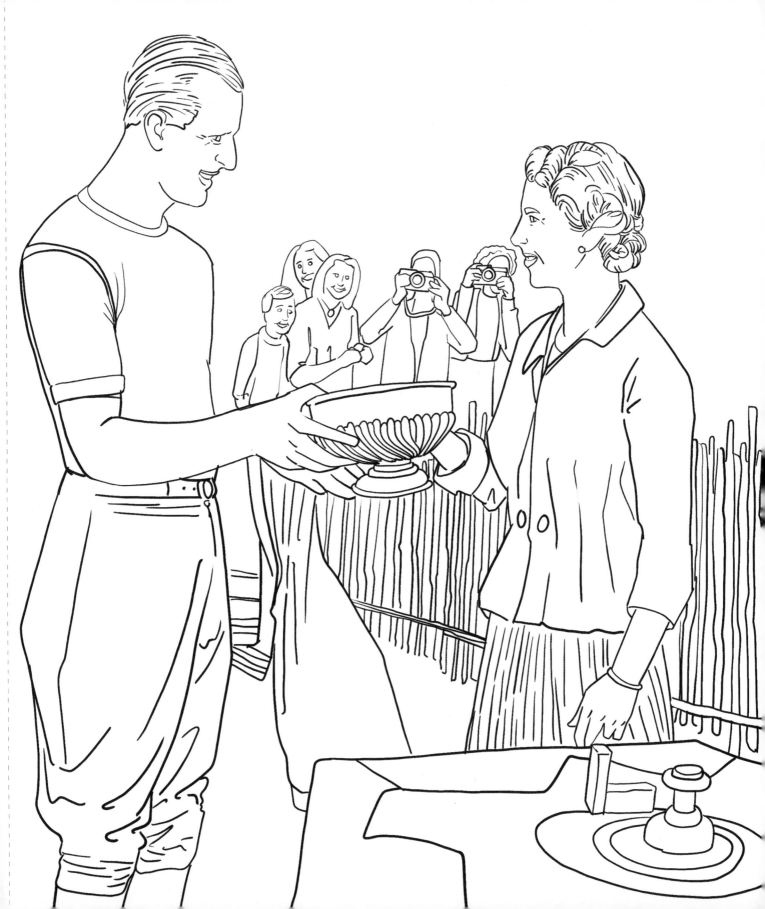

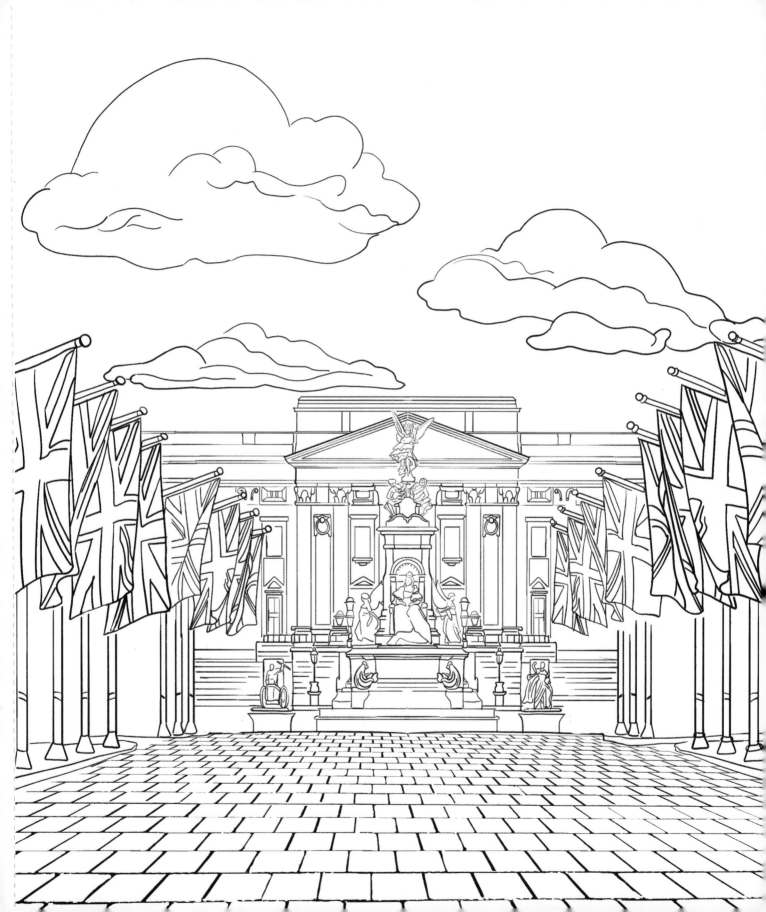

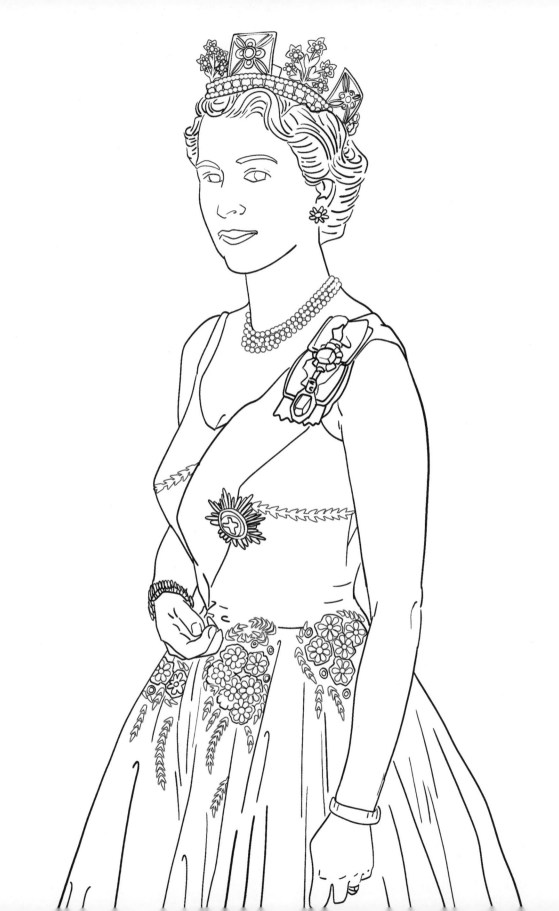

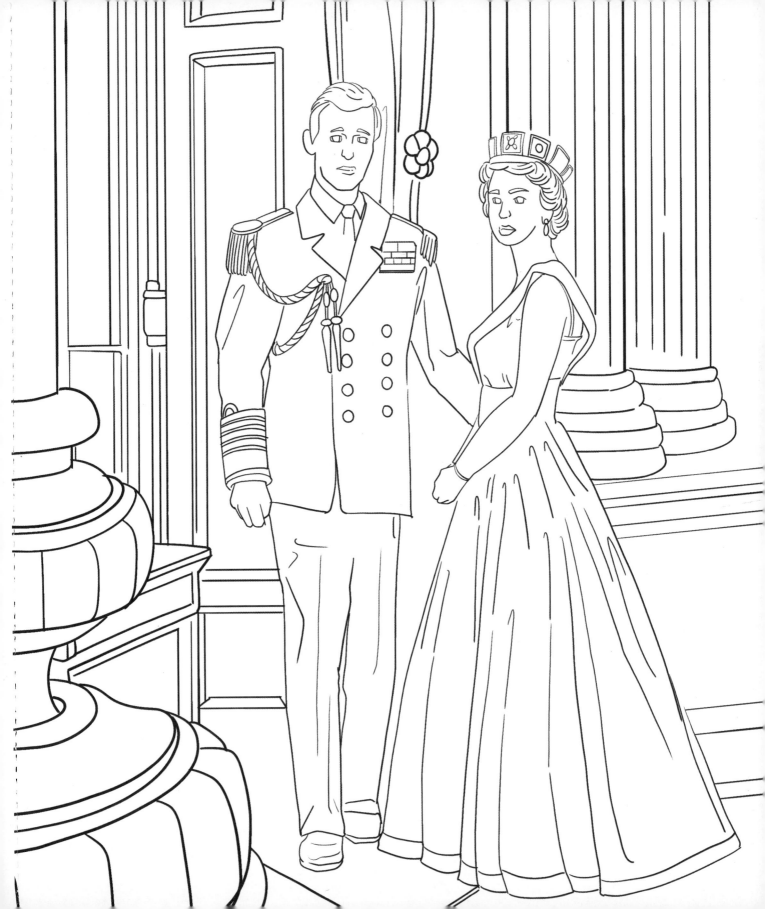

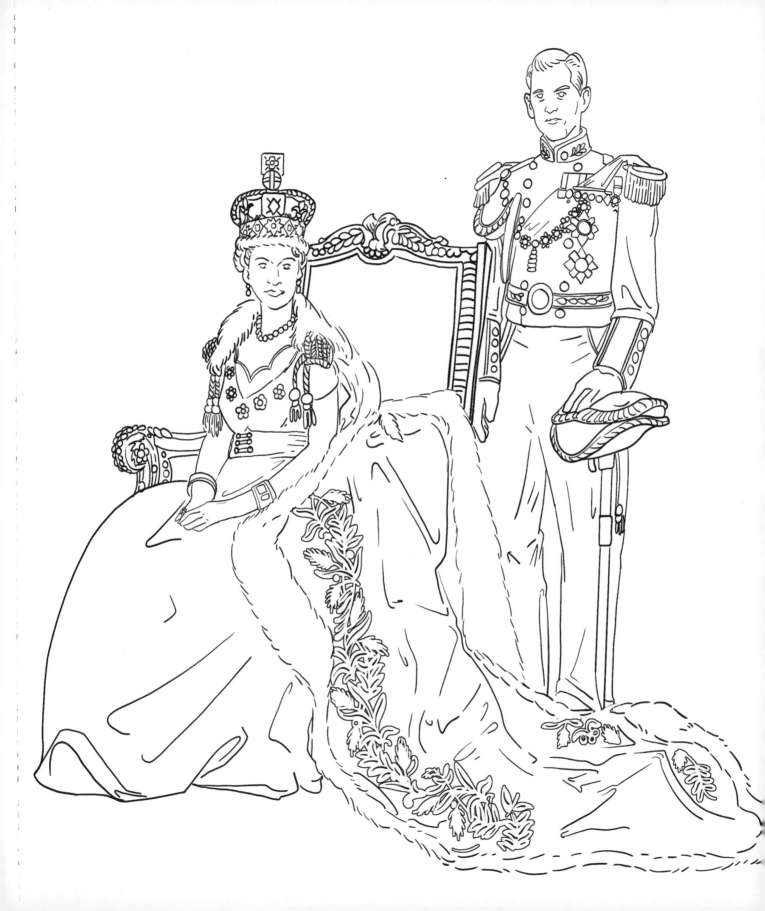

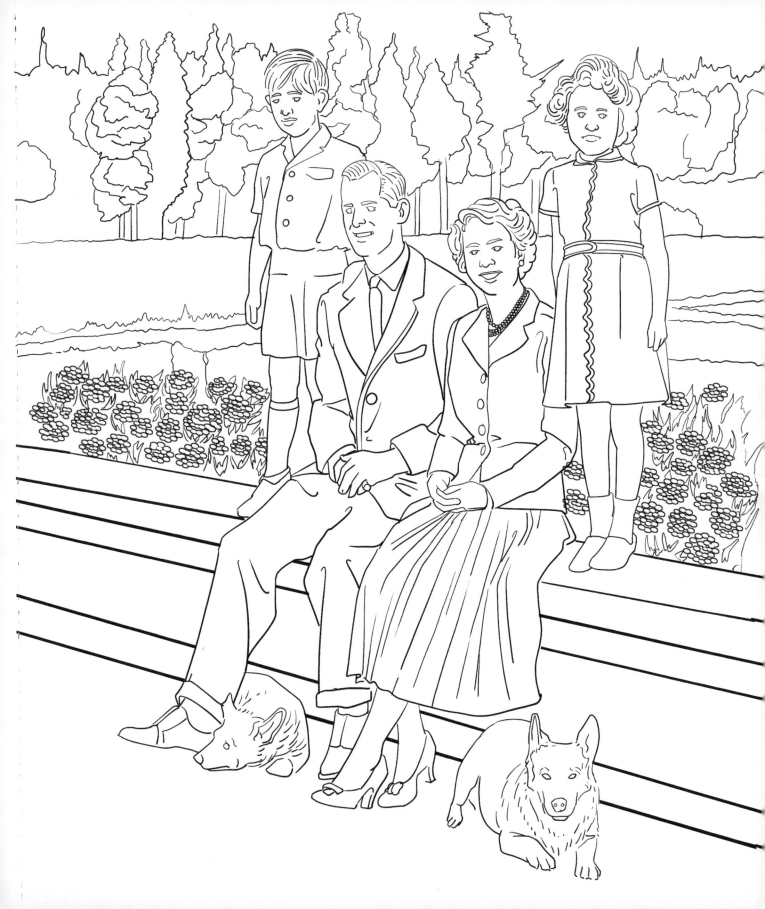

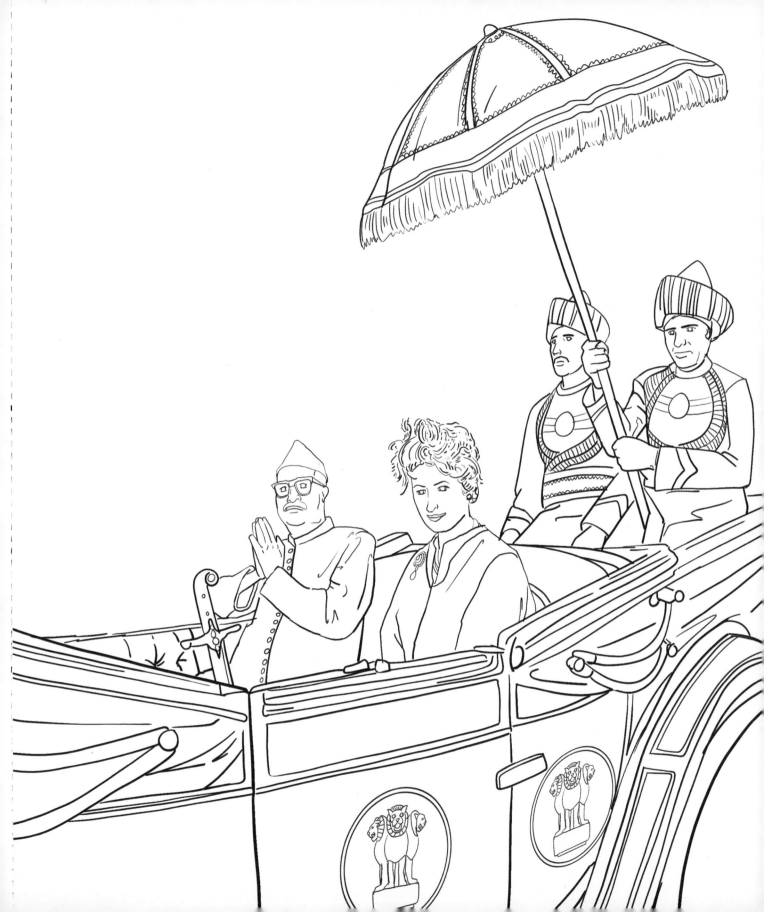

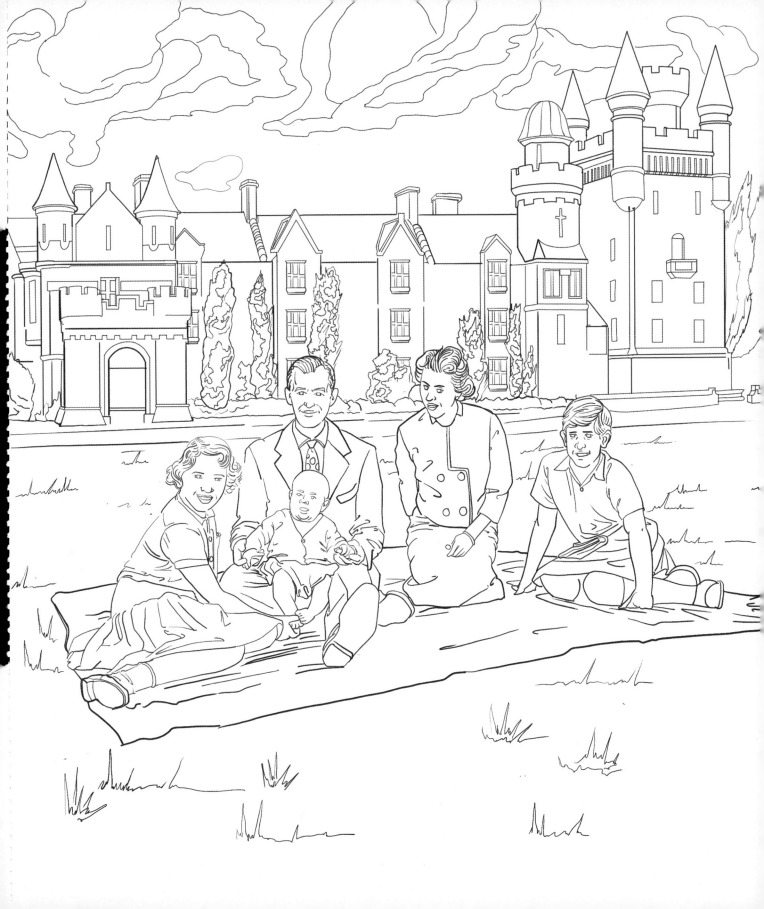

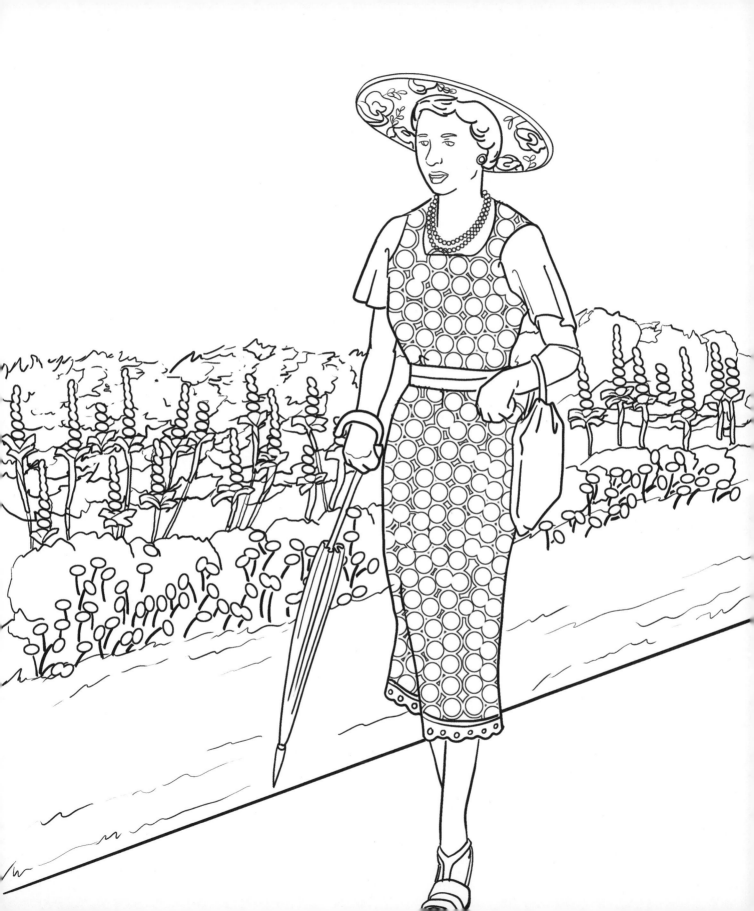

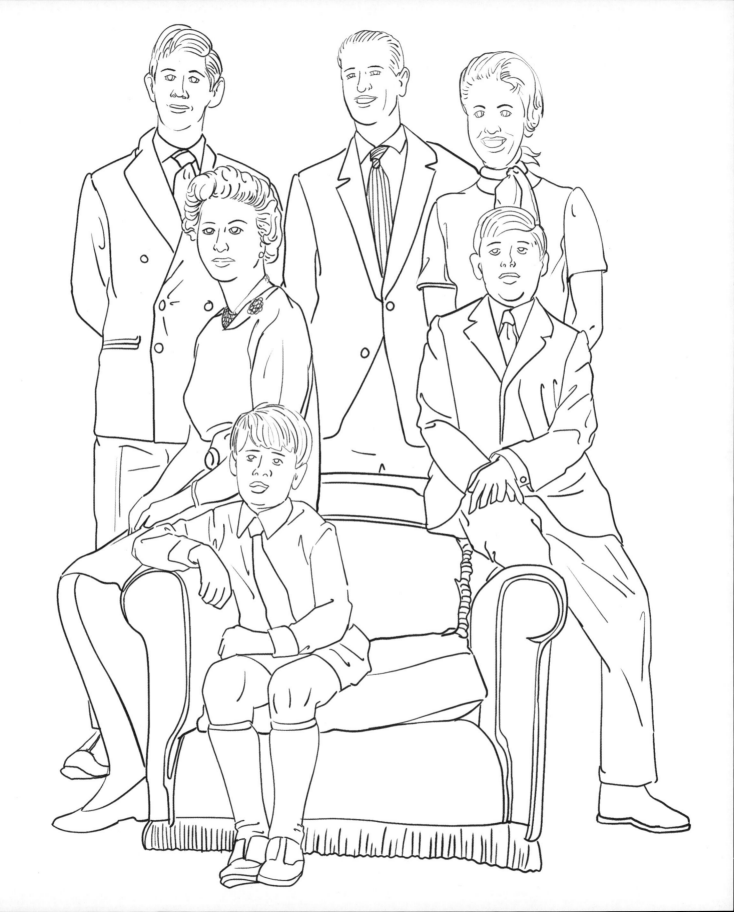

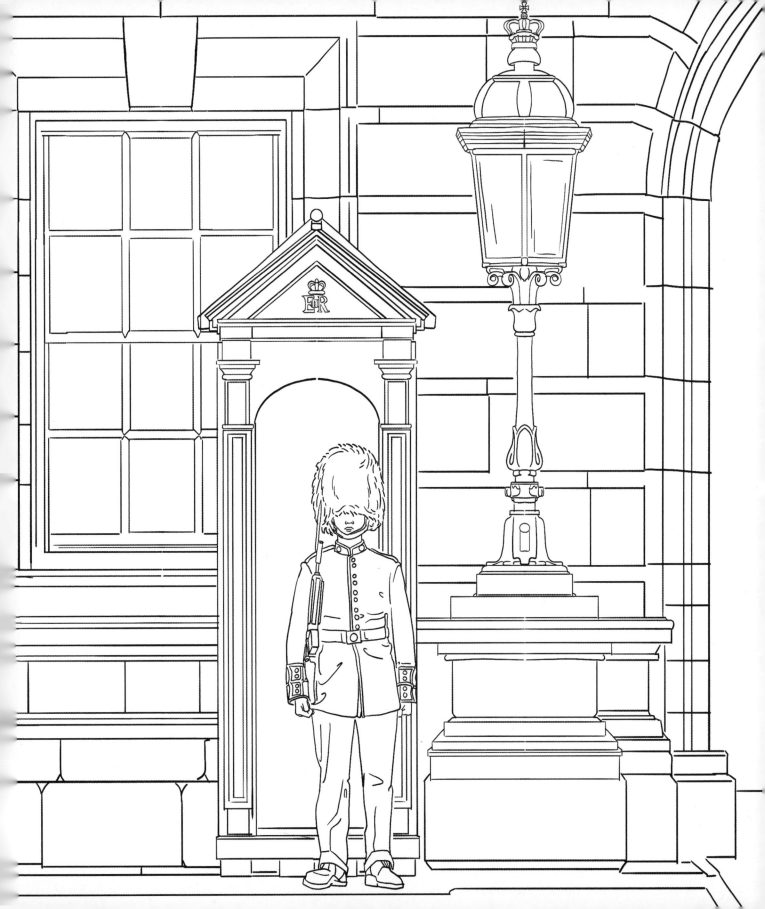

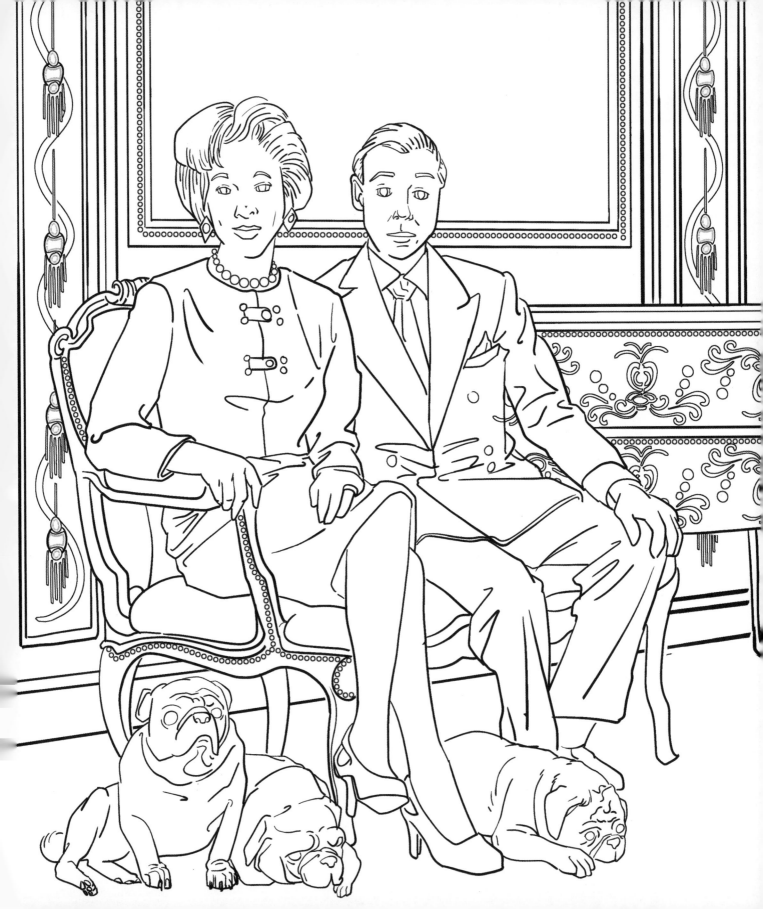

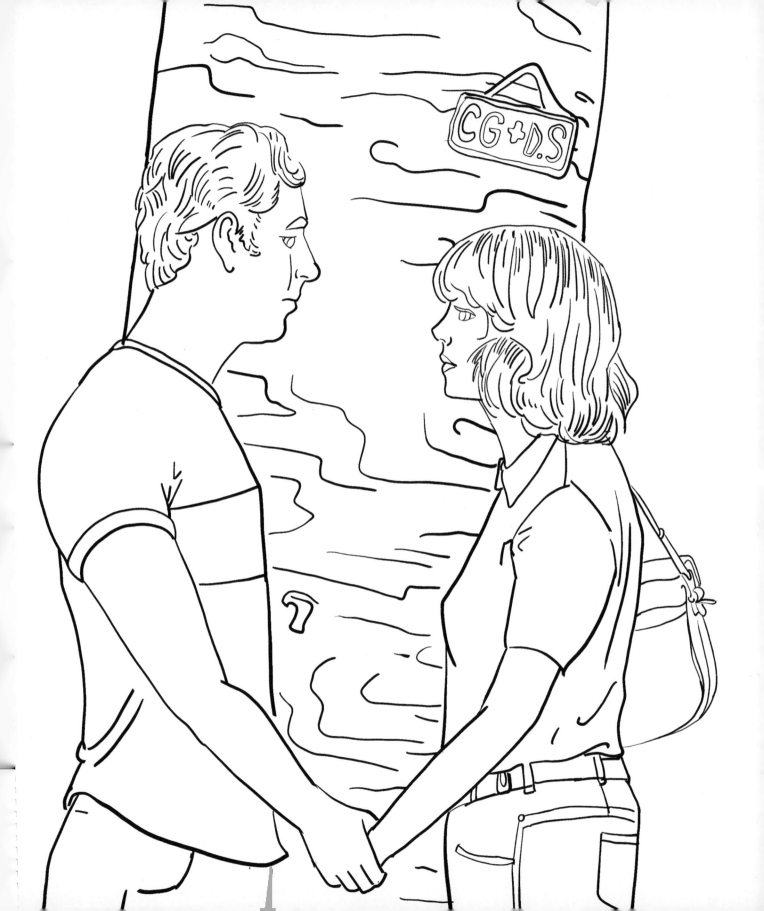

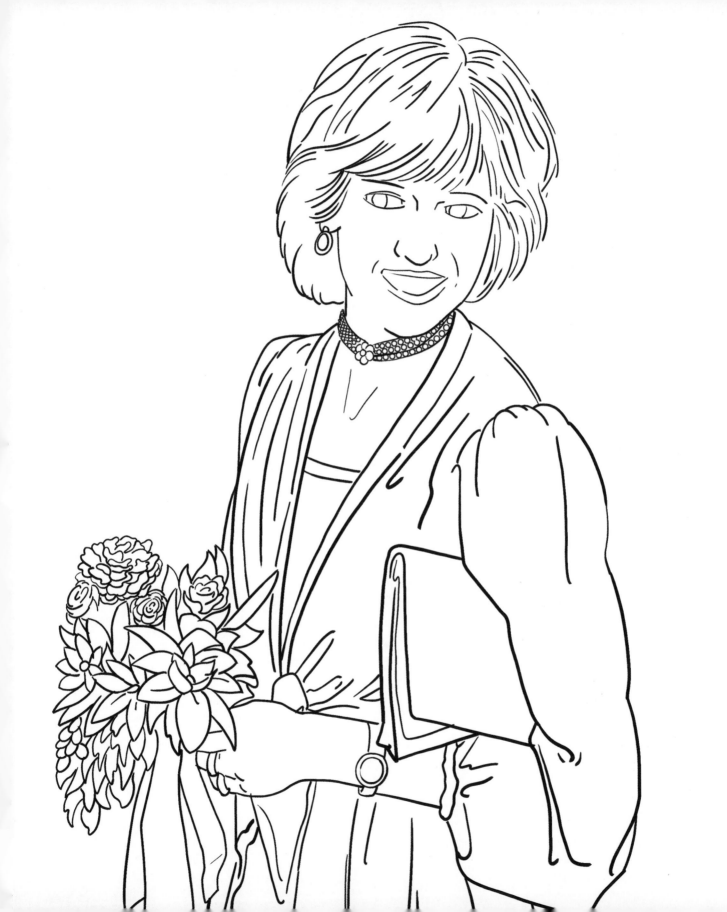

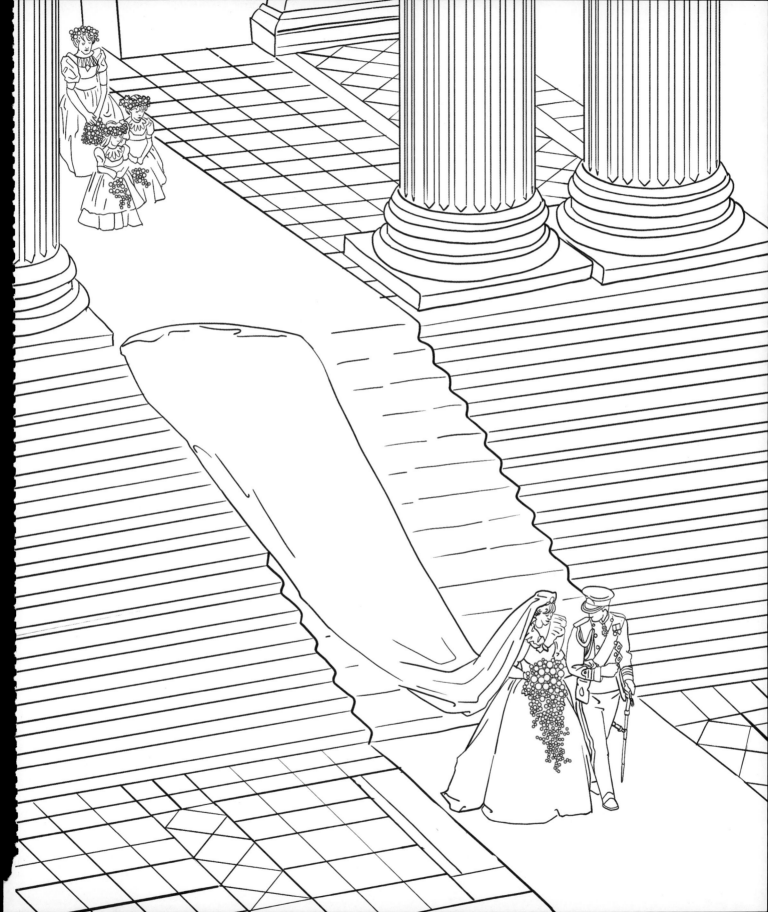

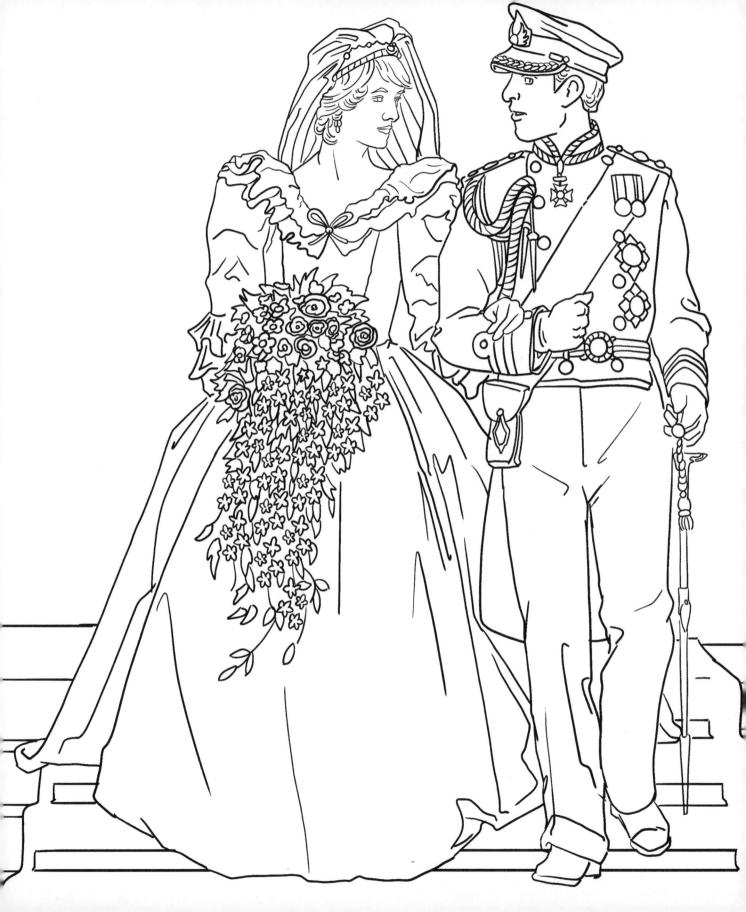

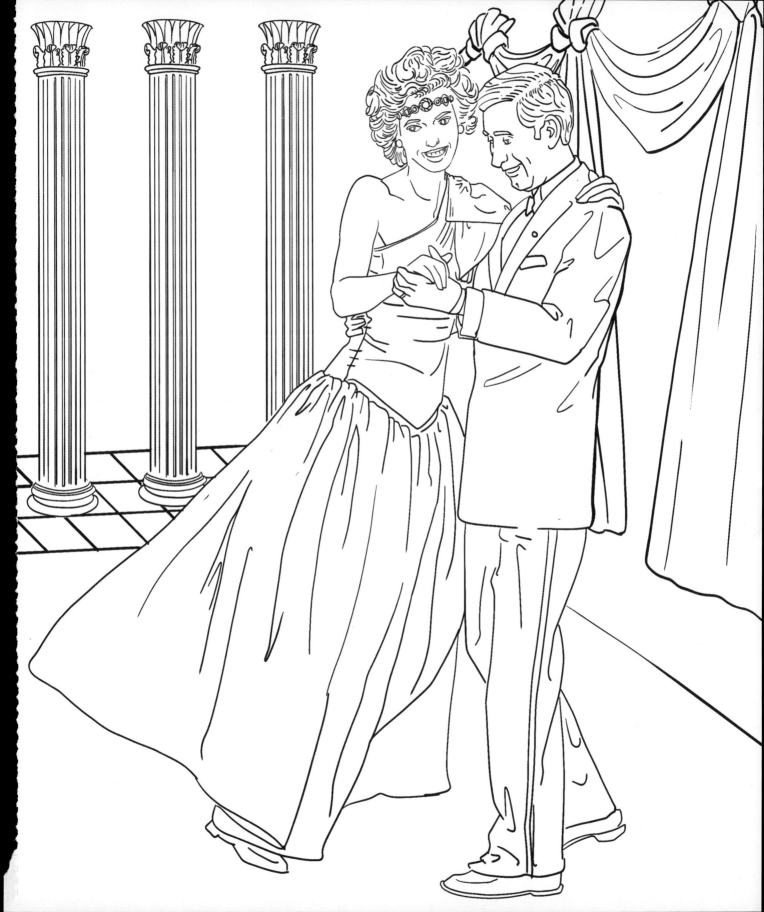

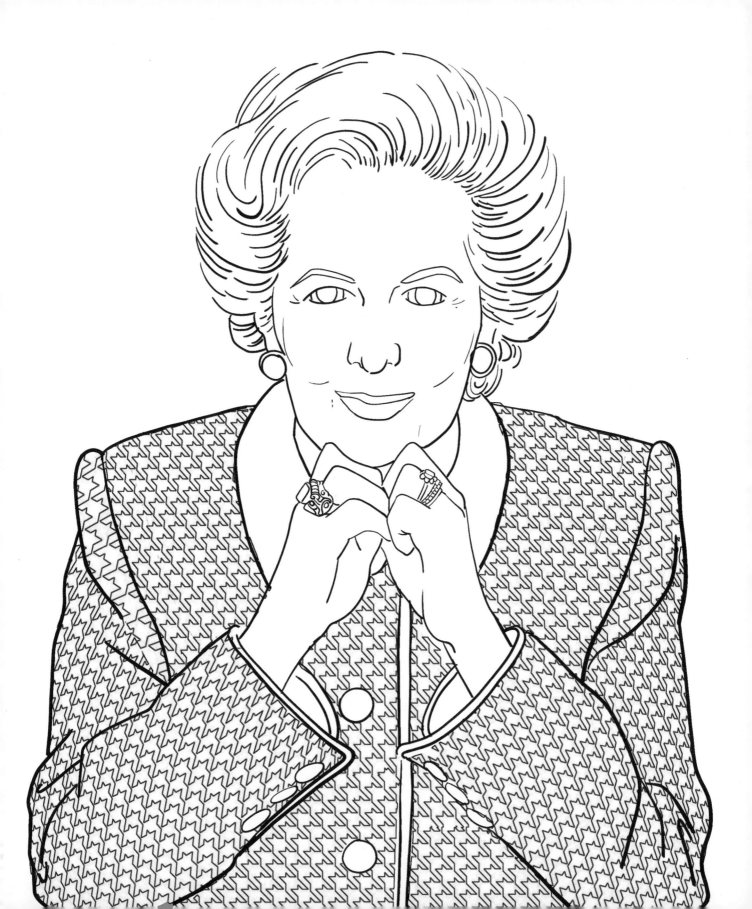

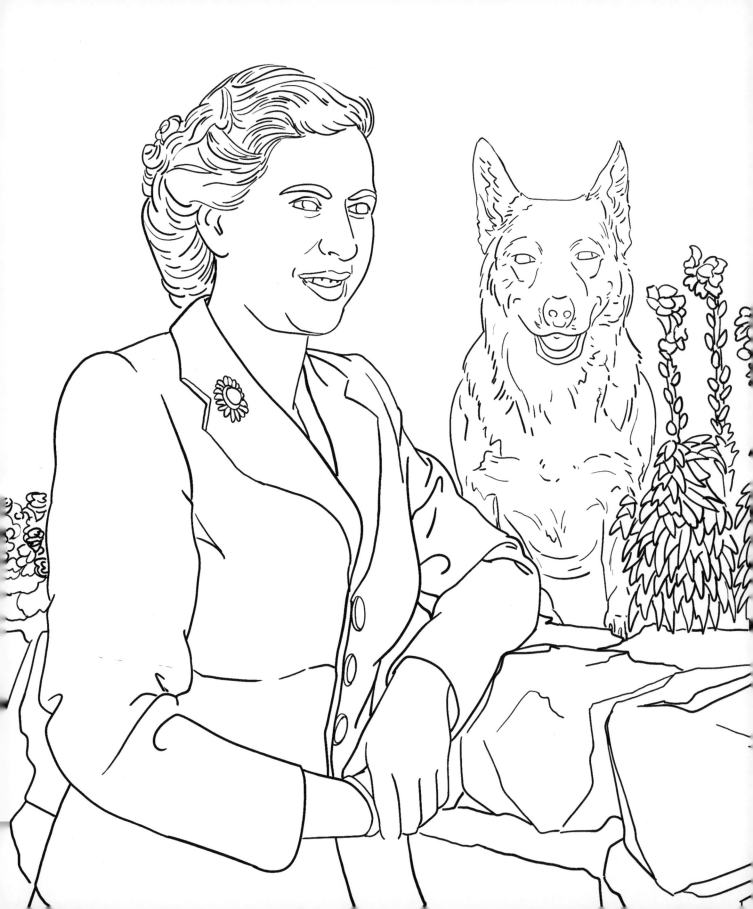

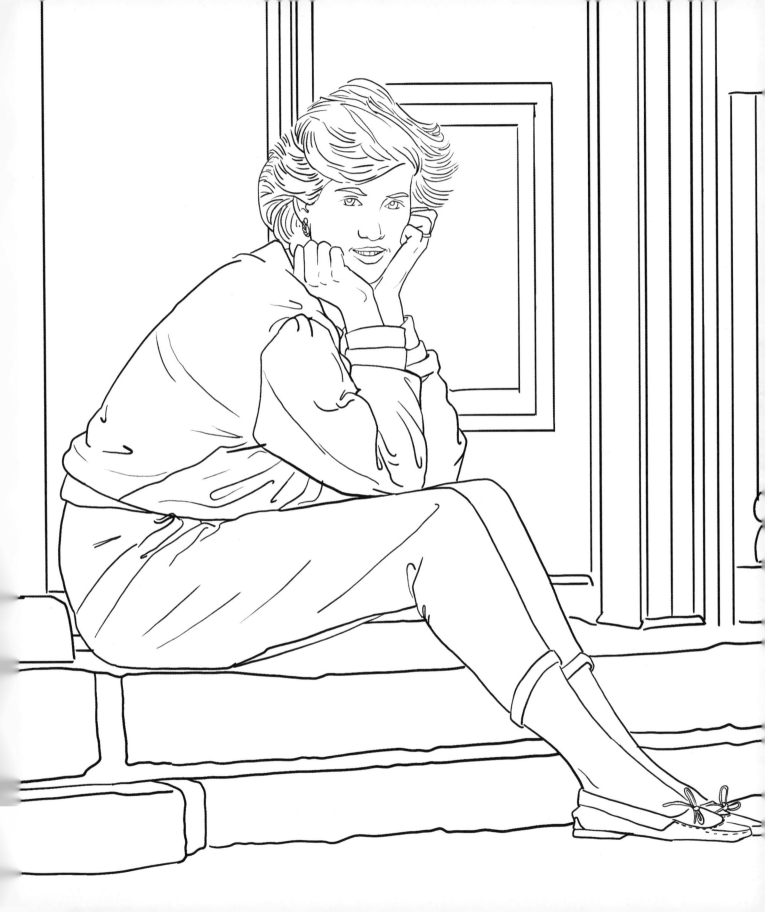

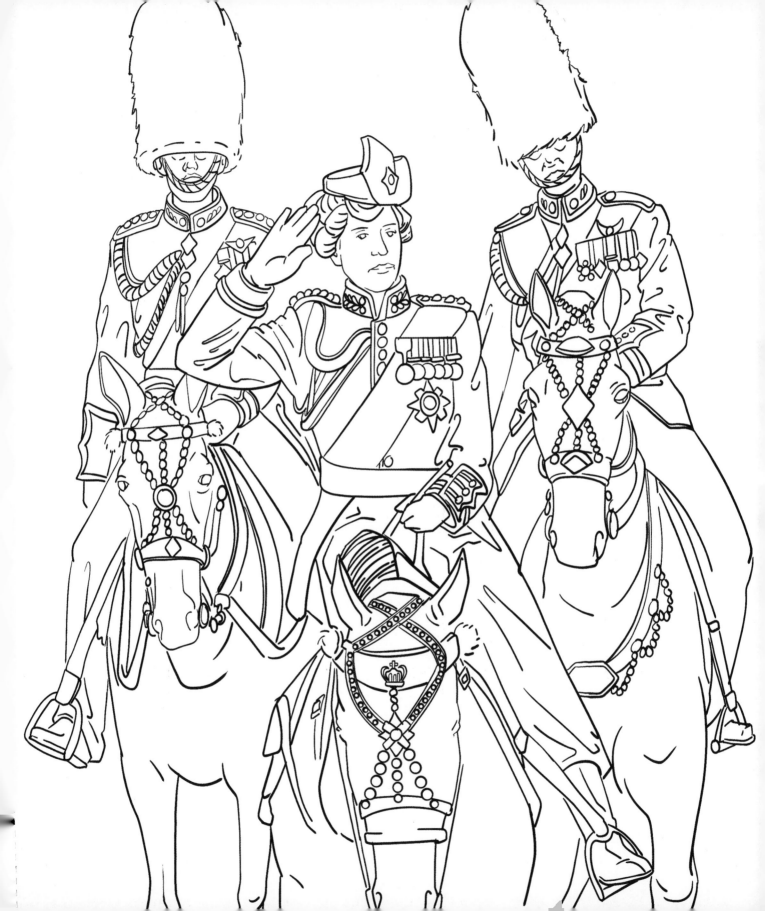

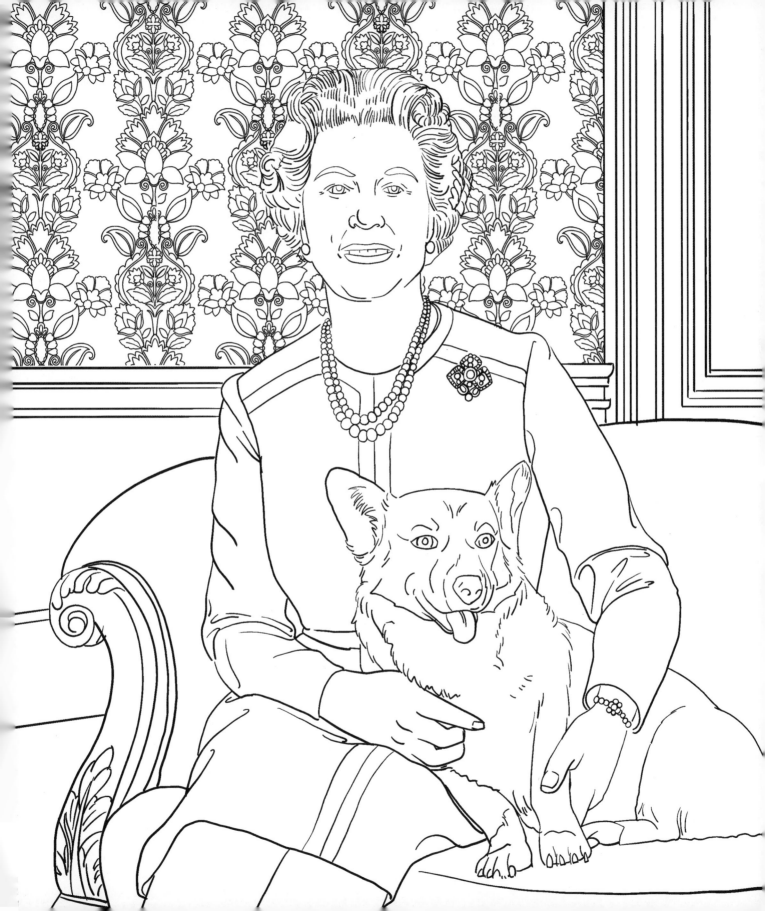

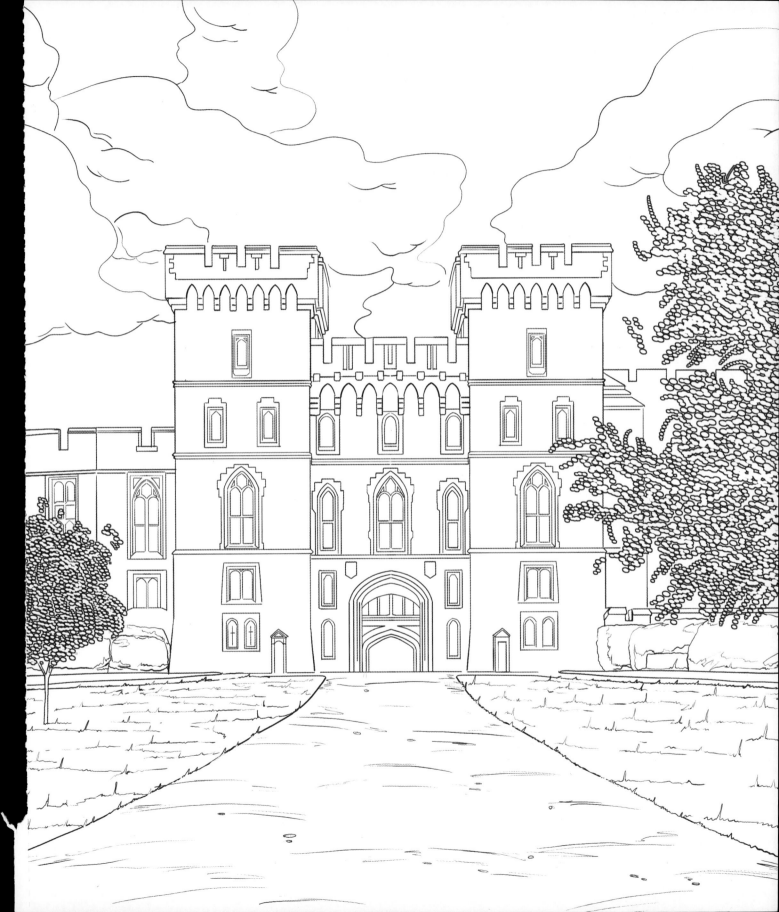

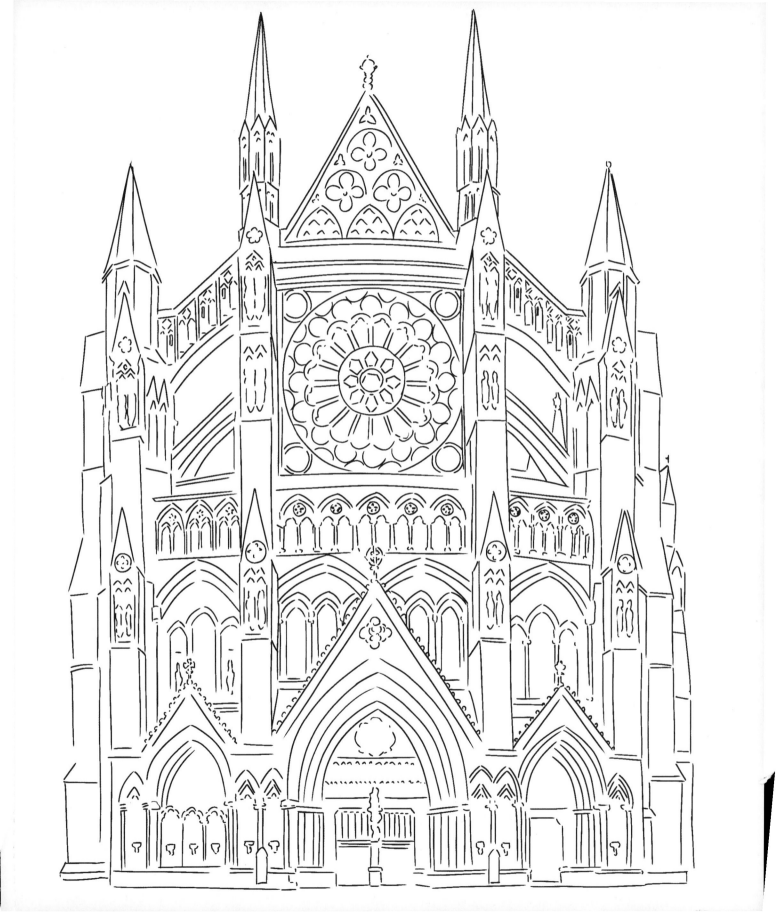